BUSH Oops

Conceived and edited by Hal Buell
Captions by Sean and Chris Kelly

Black Dog & Leventhal
Paperbacks

Library of Congress Cataloging-in-Publication Data on file
at the offices of Black Dog & Leventhal.

ISBN-10: 1-57912-641-3
ISBN-13: 978-1-57912-641-4

Design by Filip Zawodnik
Cover design by Lindsay Wolff

Manufactured in the United States

j i h g f e d c b a

Published by
Black Dog & Leventhal Publishers Inc.
151 West 19th Street
New York, NY 10011

Distributed by
Workman Publishing Company
708 Broadway
New York, NY 10003

oliticians have had a long love affair with the Photo Op – or in Washington-speak, Photo Opportunity. So much an be communicated by an effective image. A good not (and we don't mean Dick Cheney's brand) can convey respectability, trustworthiness, intelligence, kindess, honesty; the list goes on and on.

works that way sometimes, but in the wink of a camera's shutter a Photo Op can turn into a Photo Oops. Digital technology has turned the camera into even more of a sharpshooter, capturing grimaces, twitches,

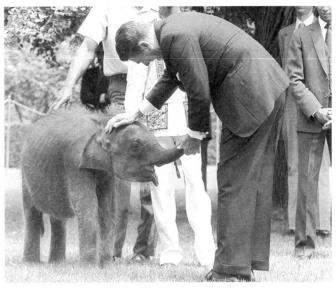

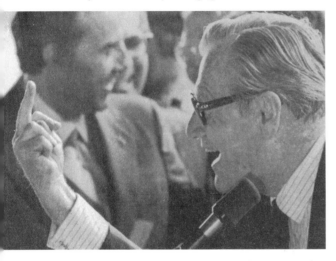

lowers, and glitches in micro-seconds. Consider Nelson Rockefeller giving the press the bird, or more recently, Howard Dean's simian scream.

oliticians have to handle babies who might throw up n their shirts, consort with critters who might peck at heir pants or poop on their vests. Politicians wear other people's clothes and shake hands with any convenient appendage in their path. As you leaf through these pages you will see that George W. is no different.

The camera doesn't hate George W. the way it did Richard Nixon. And his handlers make certain that George W. gets to the right spot at the right time.

Even so, he has had trouble with his Ops and his Oops. The Mission Accomplished photo, a picture of the President as Top Gun landing a jet on an aircraft carrier, became an ironic comment on continuing hostilities in Iraq. He gets tangled up with briefcases, papers and pets as he salutes Marine guards. The pictures roll out but the difference between what they are intended to show and what the viewers receive is the distance between an Op and an Oops.

In this era of rigidly controlled and meticulously staged presidential appearances, it is a relief to be reminded that accidents do happen, sometimes for the sidesplitting benefit of us, his captive and dutiful audience.

Enjoy Bush Oops, the latest edition.

Hal Buell

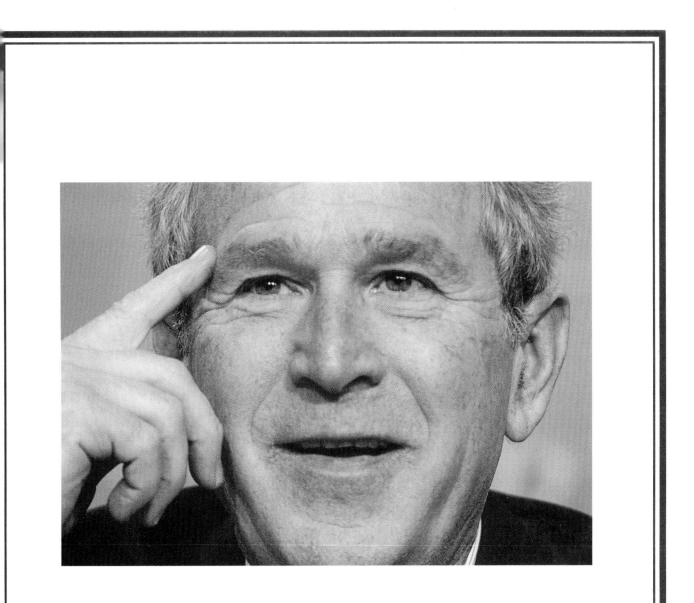

"I'm thinking of a word that begins with WMD."

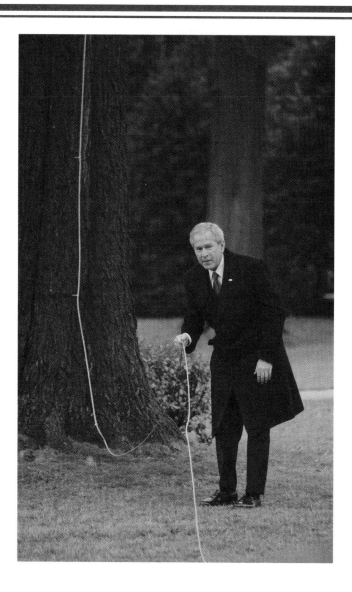

"Wait a minute! I think I got a lead to Osama's hideout."

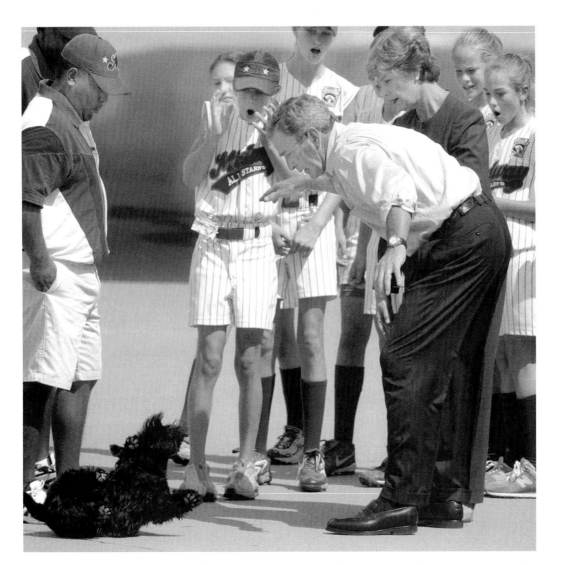

Bush flings his pet Scottie to the ground as part of his continuing "war on terriers."

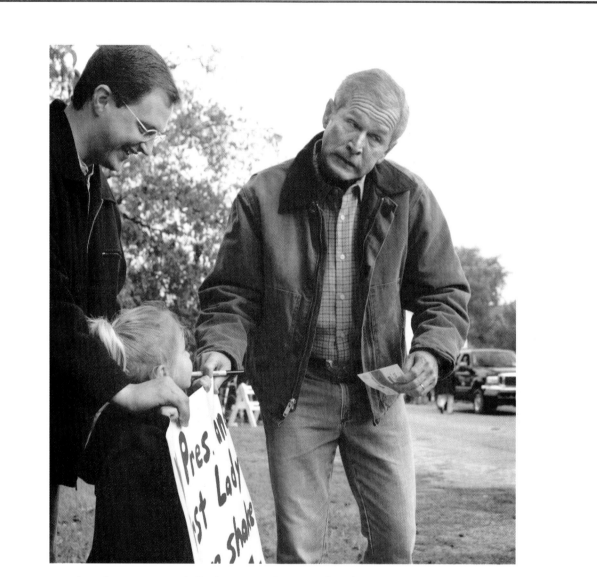

Yet another future voter falls for President Bush's favorite "pull my finger" gag.

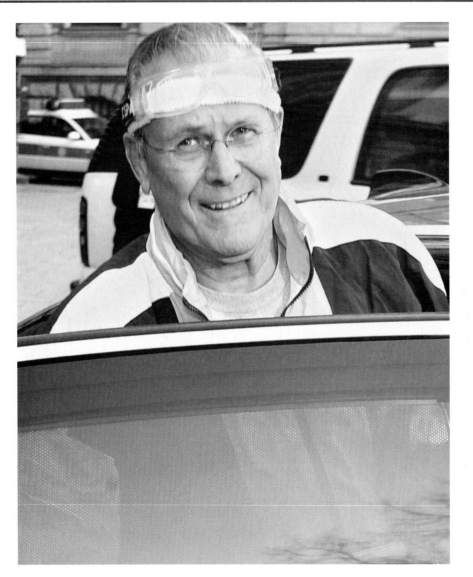

Rumsfeld leaves the palace of the wizard, after receiving a new brain.

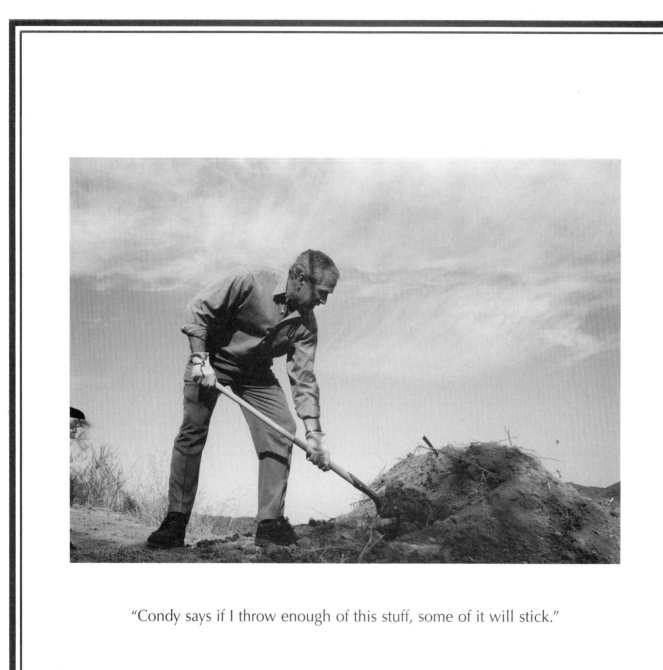

"Condy says if I throw enough of this stuff, some of it will stick."

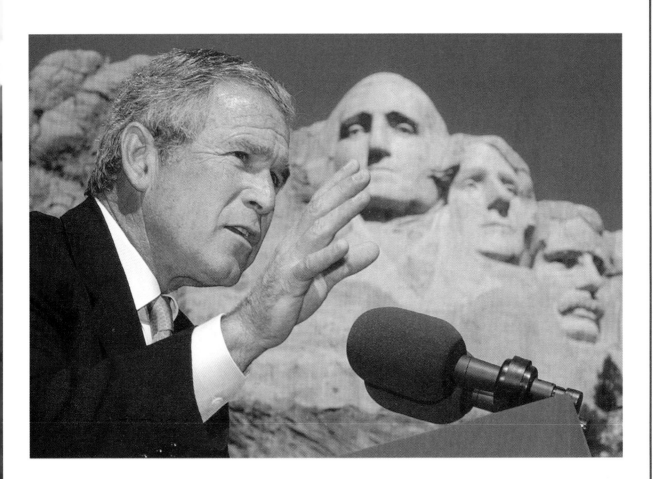

Addressing his proposed education reform, Bush asks, "How can so-called 'evolution' explain the fact that these mountains look a lot like people?"

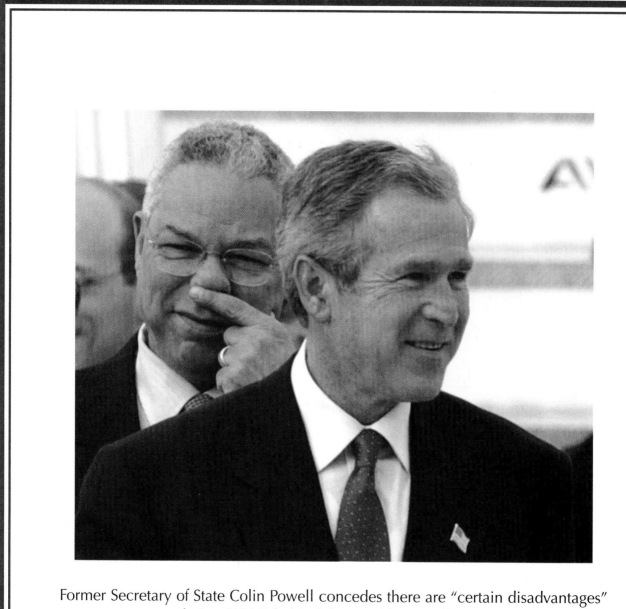

Former Secretary of State Colin Powell concedes there are "certain disadvantages" to being "100% behind the president at all times."

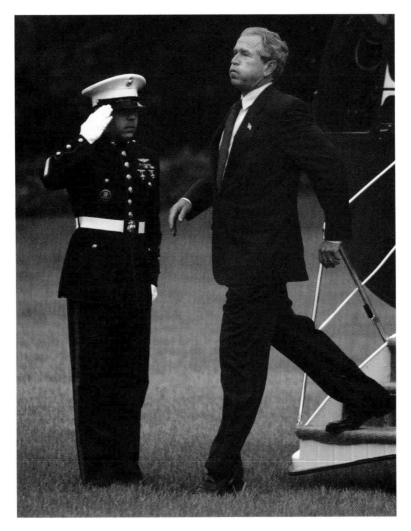

MISSION ACCOMPLISHED!

"How many Iraqis does it take to screw in a lightbulb?
Who cares - there's no ELECTRICITY! Ba-da-BOOM!"

"Over There! Over There!
Those weapons are somewhere over there!
And so the Yanks are going,
In tanks they're going,
And they won't come home 'til . . .
Ummmh . . ."

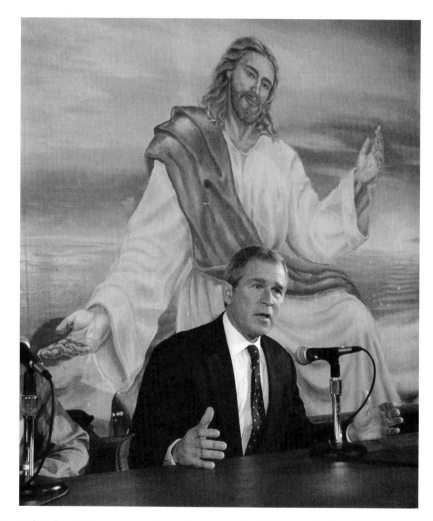

"Just think - if those ancient Romans had banned the death penalty,
Jesus couldn't of died for our sins!"

"Oh, my god, am I in time? This is the governor, do not execute that woman! Hahahaha! Of course I'm kidding. Gotcha!"

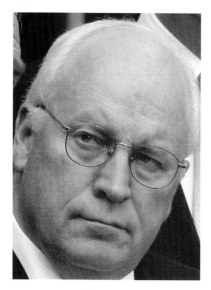

Happy

Sad

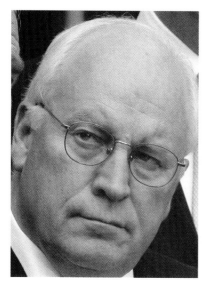

Confused

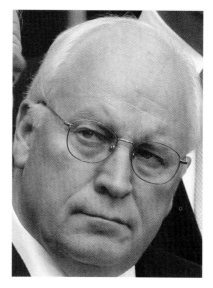

Astute

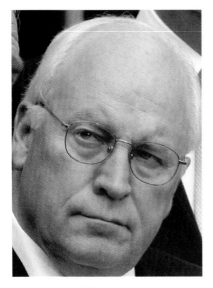

Passive

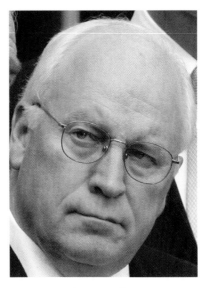

Aggressive

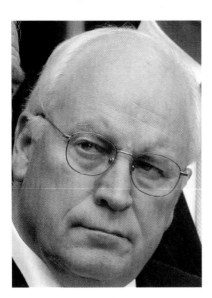

Awake

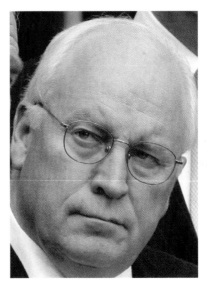

Asleep

19

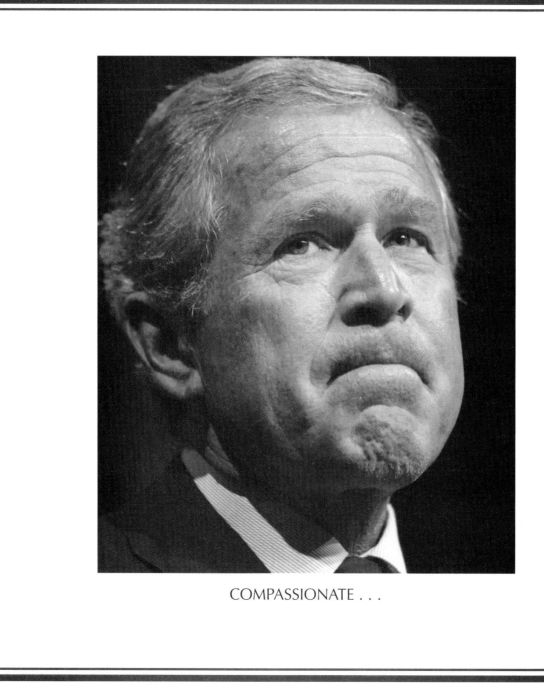

COMPASSIONATE . . .

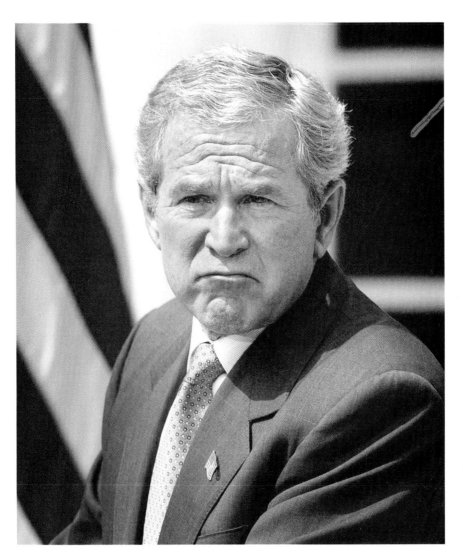

. . . CONSERVATIVE

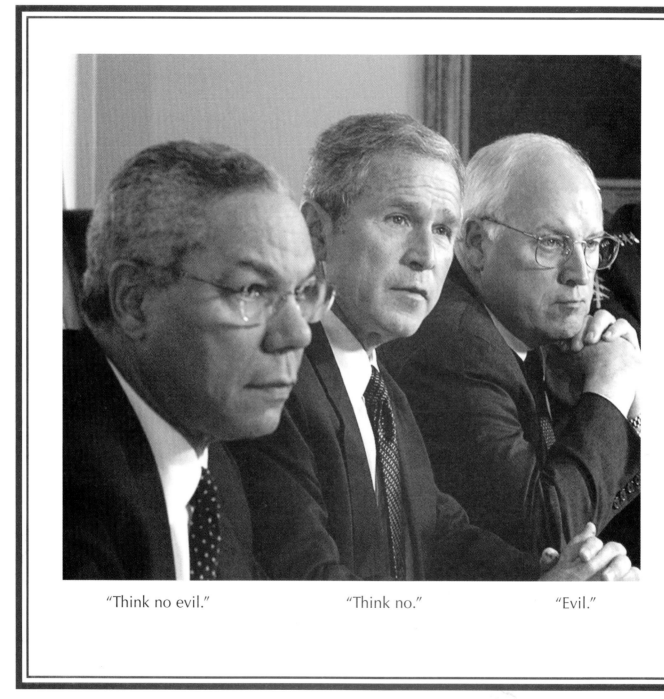

"Think no evil." "Think no." "Evil."

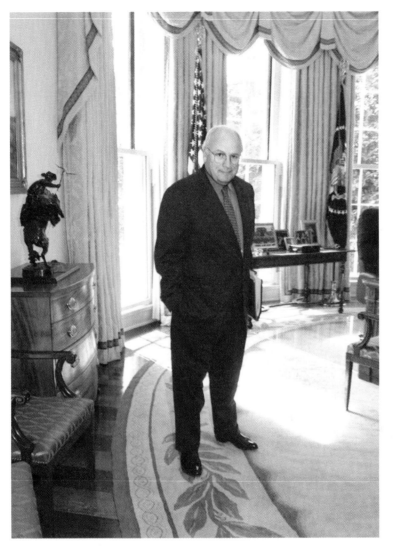

Cheney in conference with his closest advisor, Beelzebub - who is, unfortunately, unphotographable.

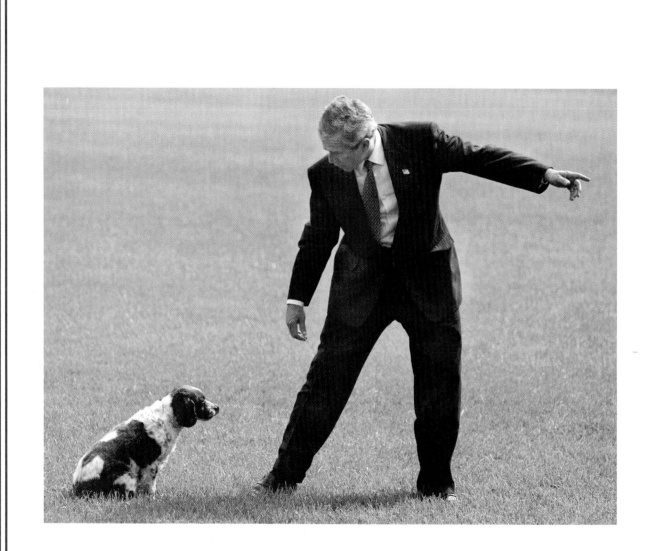

Adhering to established White House policy, presidential dog Spot declines to follow orders until "clearing them with Dick."

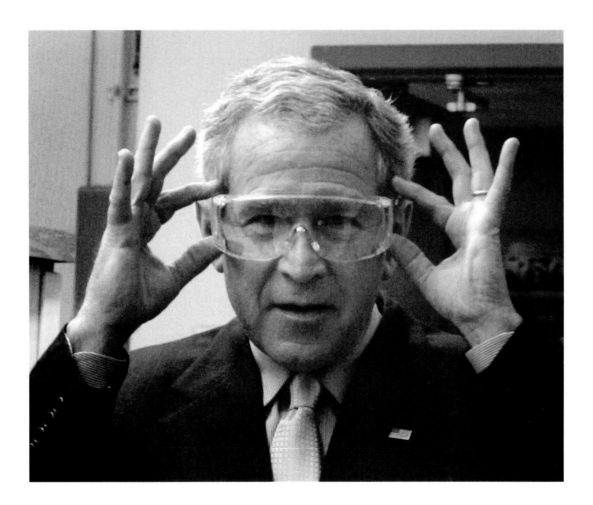

"I'm going to New Orleans. You sure these will work under water?"

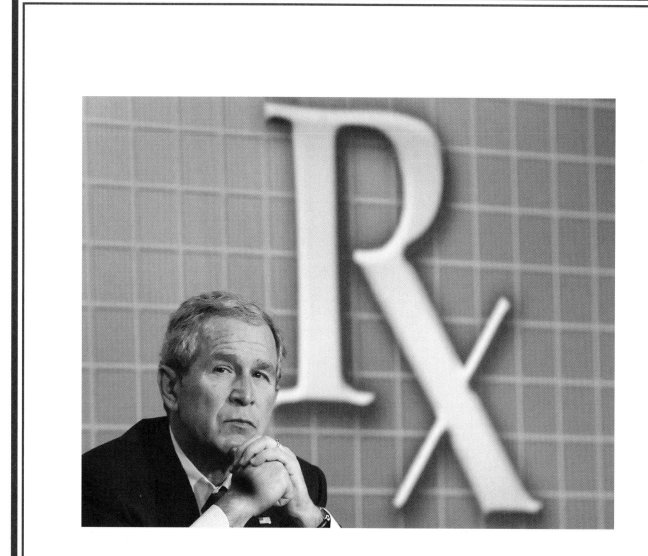

"Well, I've lost my Colin but at least I still have my Dick."

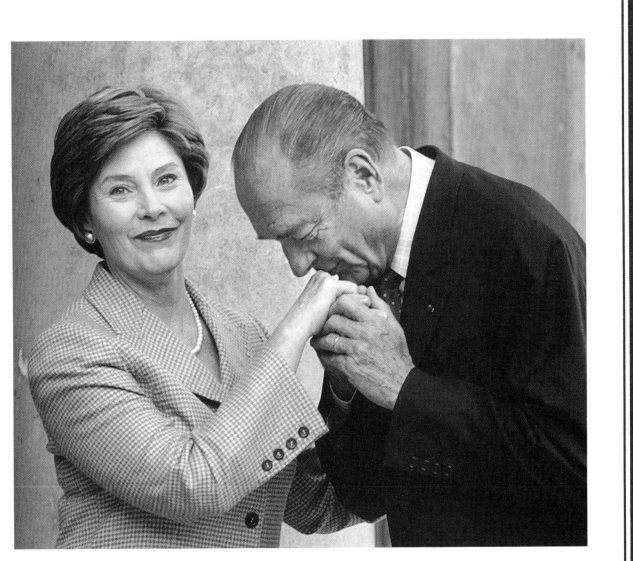

"Your 'ands, madam - they smell like - 'ow do you say it? Valium?"

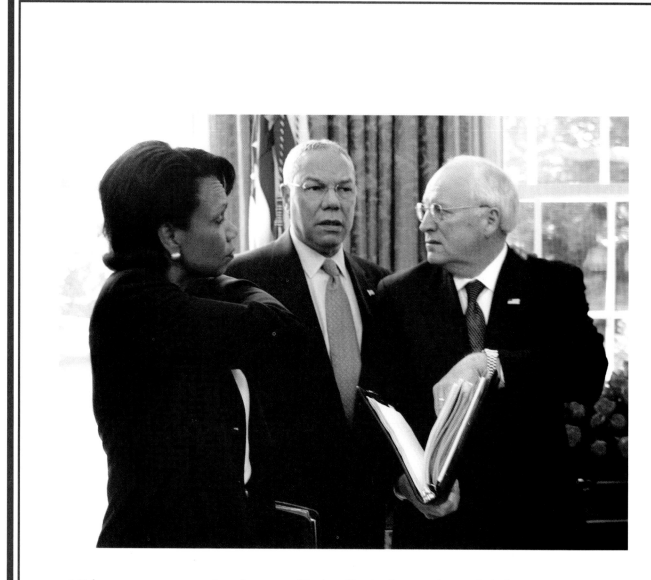

Mideast experts examine the new "Federally Authorized" English-language version of the Koran, in which *jihad* is translated as "faith-based initiative."

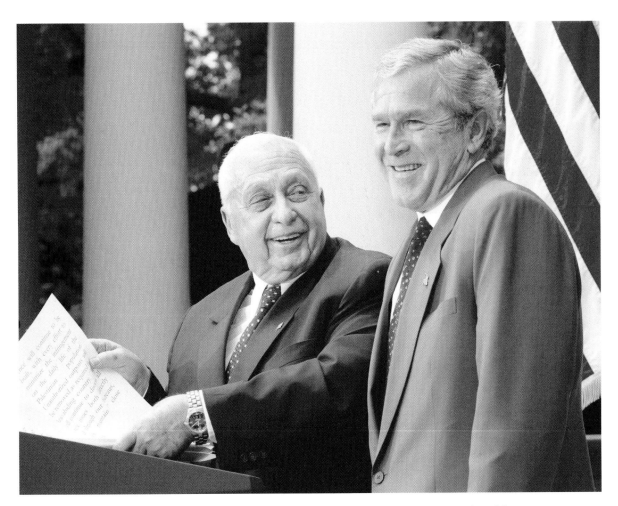

"Road map, schmoad map. As long as you've got your health."

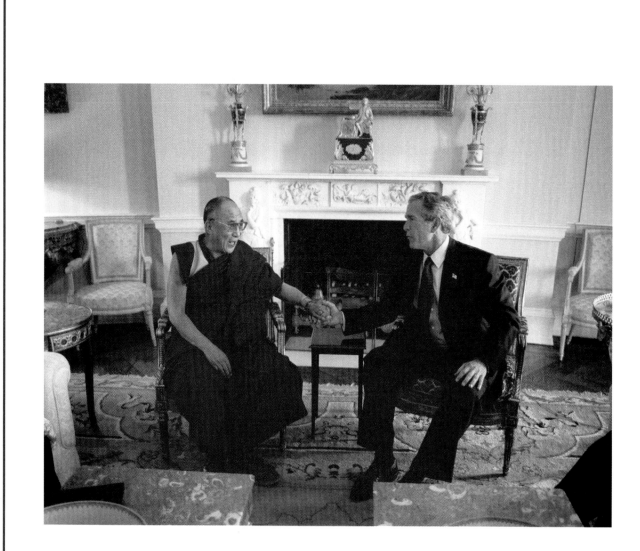

Dalai Lama tells Bush that in previous lives Bush had been Czar Nicholas II of Russia, King Louis XVI of France and King Charles I of England.

"Iran. Iraq. Gimme a break, I was only off by one letter!"

"Next question. Over here."

"Hmmmmmm"

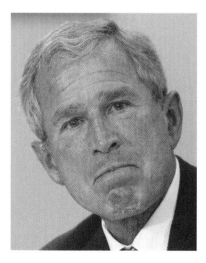

"Hmmmmmm"

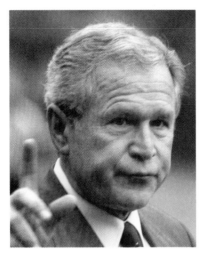 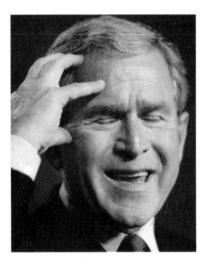

"Wait a minute!" "Laura!"

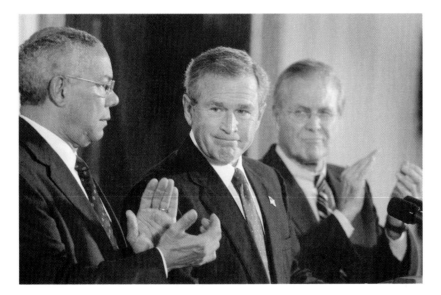

"Nice work, sir!"
"Brilliant, as usual!"

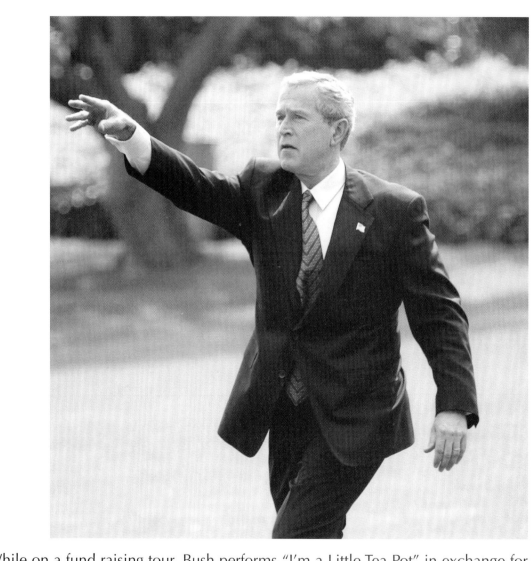

While on a fund raising tour, Bush performs "I'm a Little Tea Pot" in exchange for 60 grand from some guys who own a lead mine.

"Ooh, I'm in a hurry! I've got to make another White House leak!"

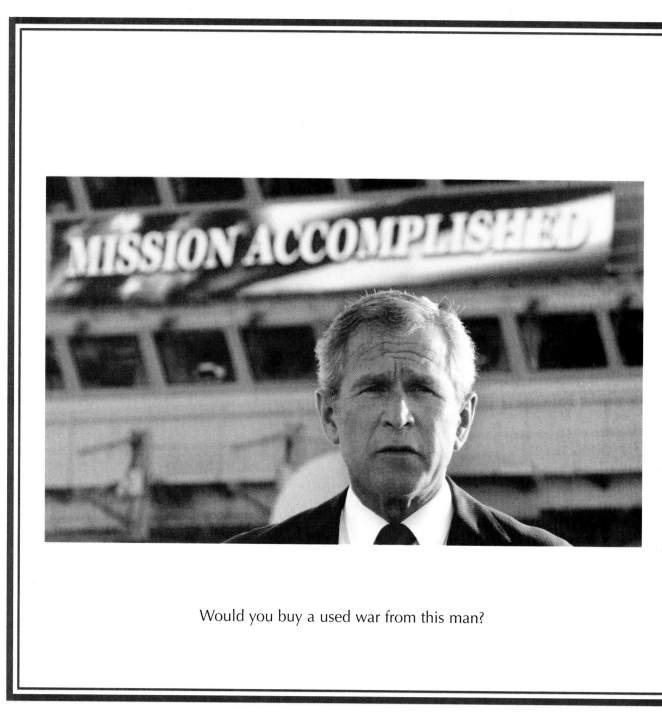

Would you buy a used war from this man?

"Jeez! I could swear it was there when I woke up this morning . . ."

"What did I do, to be so black and blue?"

"What did *I* do, to be so black and blue?"

The Problem.

The Solution.

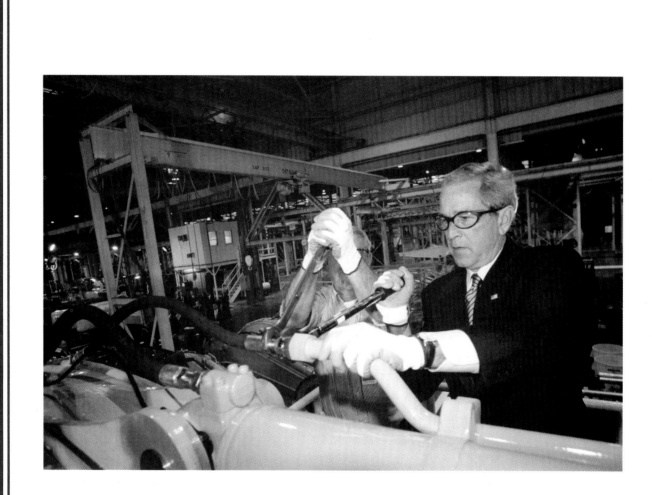

"See, you don't need to outsource these jobs to China."

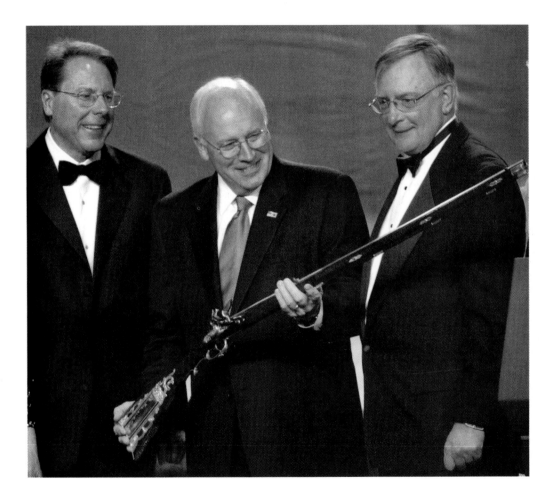

"I can't wait. A nice afternoon, a couple of good friends, a few beers."

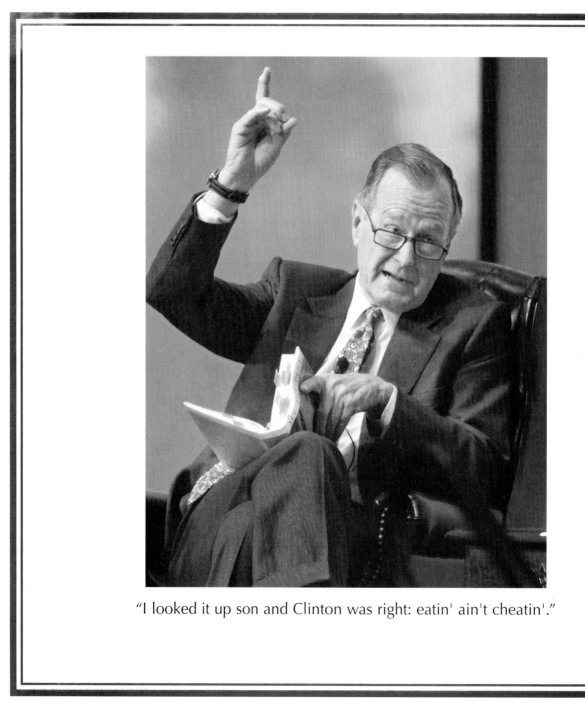

"I looked it up son and Clinton was right: eatin' ain't cheatin'."

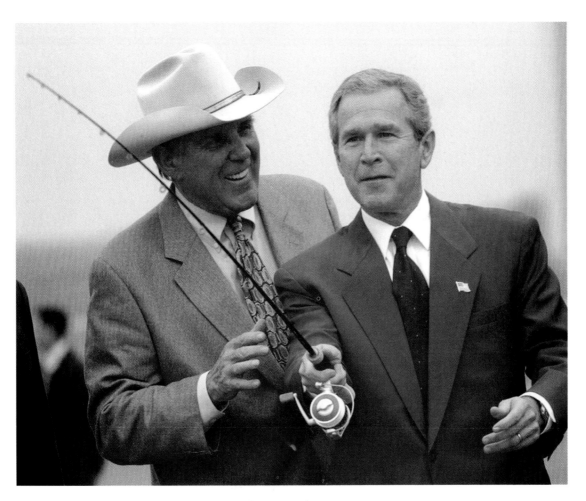

"And it works even better in water!"

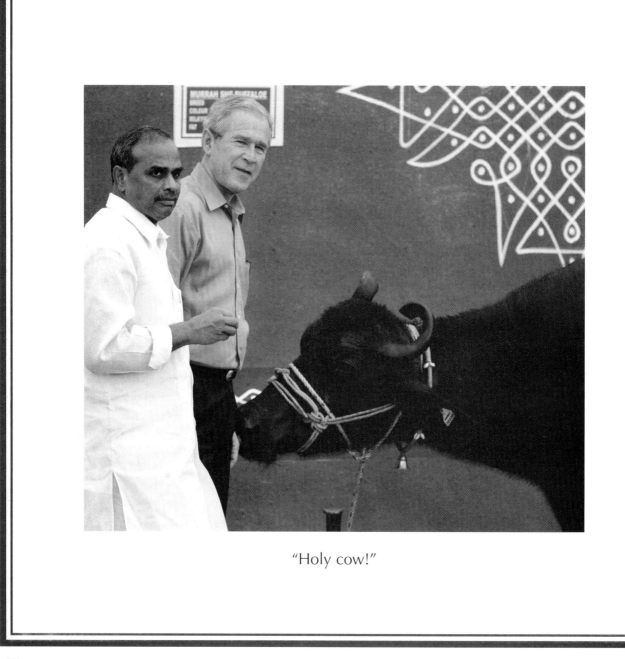

"Holy cow!"

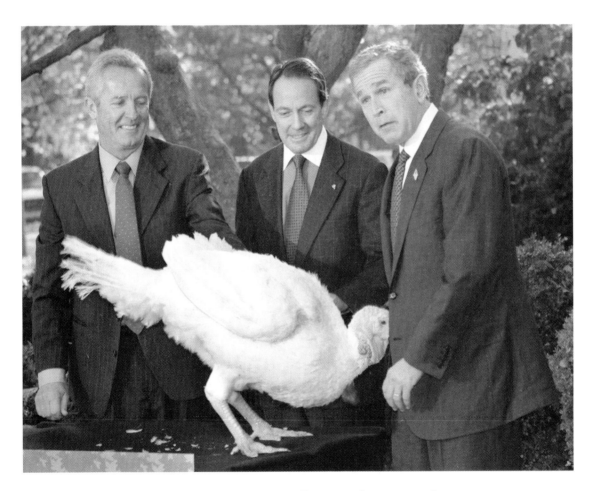

Desperate for Mideast allies, Bush woos Turkey.

"This isn't one of them tree-huggin' high breeds is it?"

"You're not going to grab my ass, are you?"
"In your dreams!"

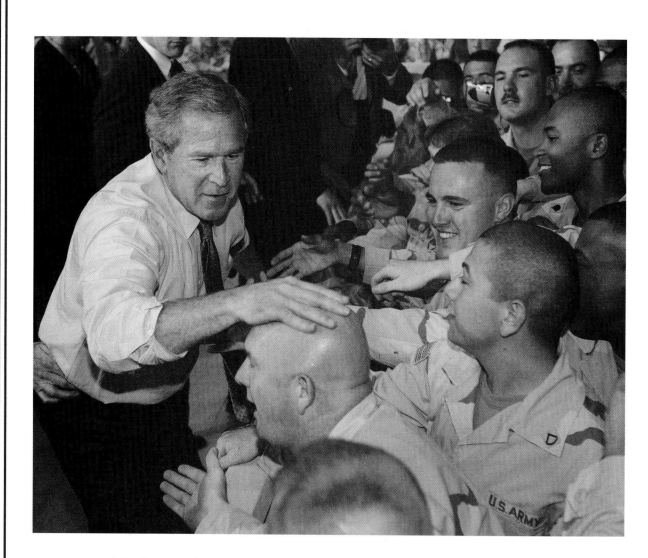

"Curly?! Ho-ho, Mr. President, how do you come up with them?"

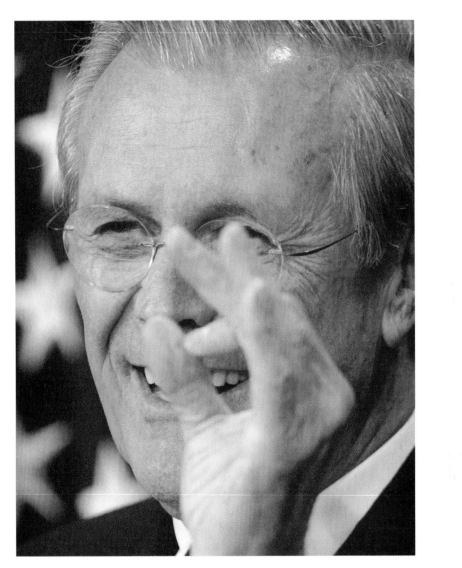

Rumsfeld assures public that rising US casualties, increasing sabotage incidents and utter humiliation were all elements of "carefully thought-out pre-war strategy."

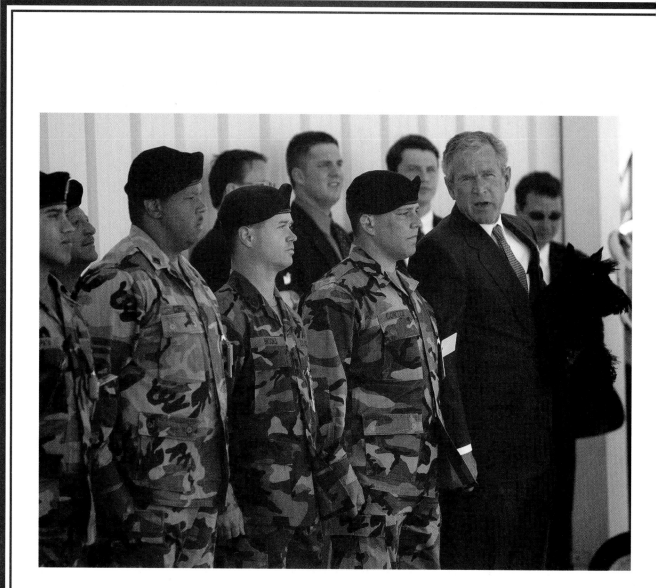

"You'll like Iraq. It's real nice. Of course, I wouldn't send a dog there . . ."

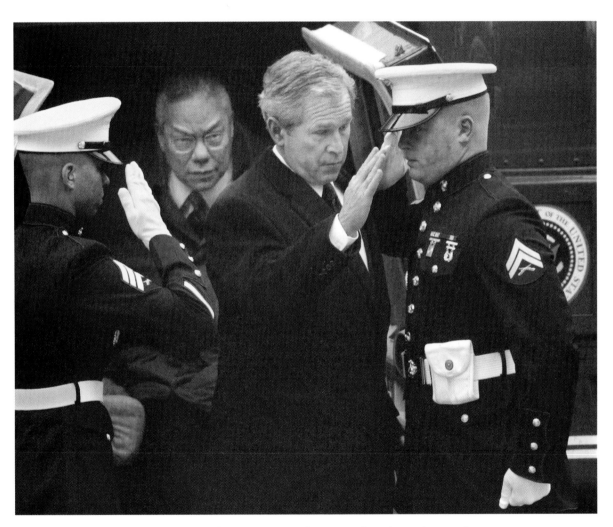

"Hey, soldier. Run and get me a turkey sandwich with cranberry sauce.
Bring it to me and I'll give you half."

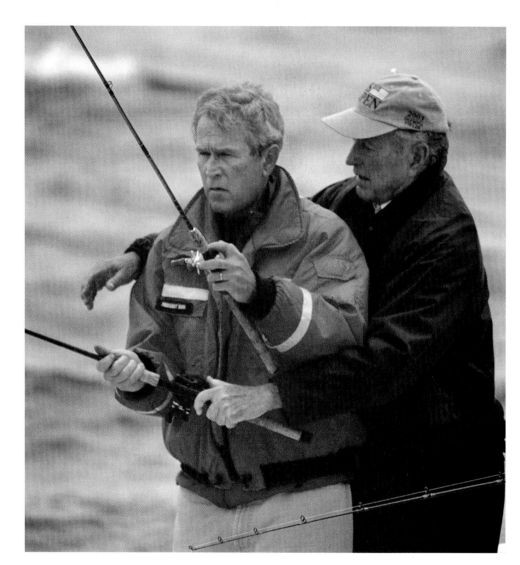

"Give a man a fish and you feed him for a day - but eliminate the inheritance tax and you've hooked him for life."

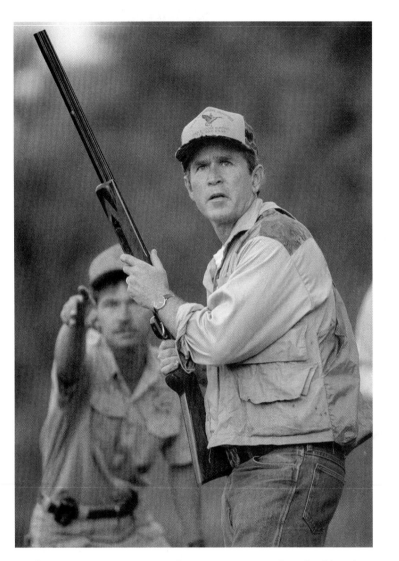

"That's not a peasant! That's just some kind of bird."

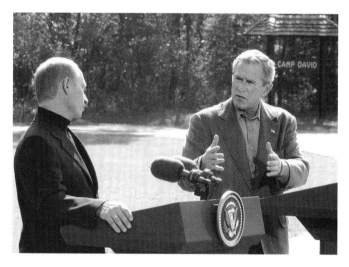

"Before we start negotiatin' here, Vlad, there's somethin' you should know about me. Somethin' personal . . ."

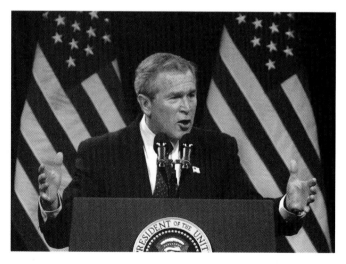

"And then I told the Russian premier - I told him straight out. I said, Mr. Putin, lemme tell you the kind of man I am . . ."

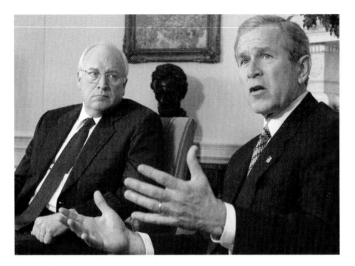

"Now that's the kind of exaggerationisms you see in the so-called liberal media. What I really said was somethin' more like . . ."

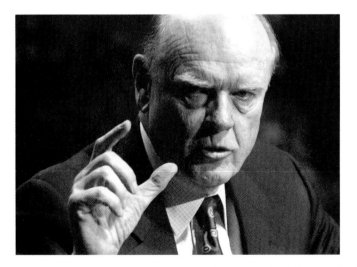

"In the light of recent evidence, the President would like to slightly revise certain previous statements . . ."

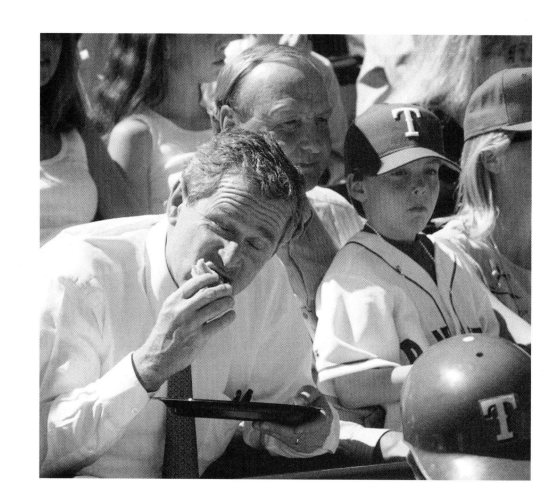

President takes break from rescinding decades of habitat protection on public lands to attend ball game and enjoy a juicy "endangered species burger."

Chinese Taipei

"Hey Lee Yuan, it's only been an hour since lunch and I'm hungry again!"

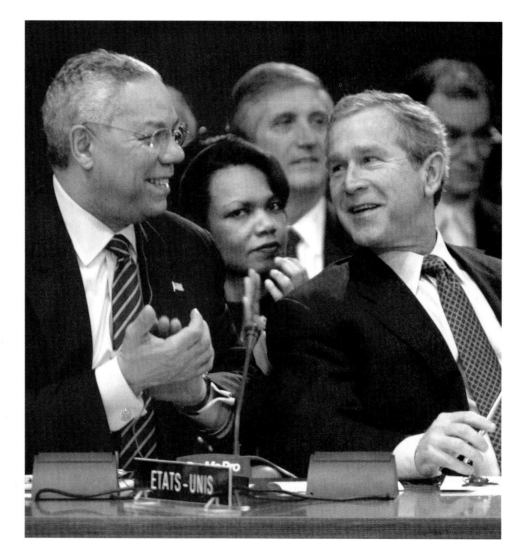

Rumsfeld gets a well-deserved laugh from Bush and Powell, as he thanks members of the Coalition of the Willing for helping US to make "a Mess o' Potamia."

"Oh, just shut up!"

When Freedom's foes attacked the American homeland, the Commander in Chief took decisive action.

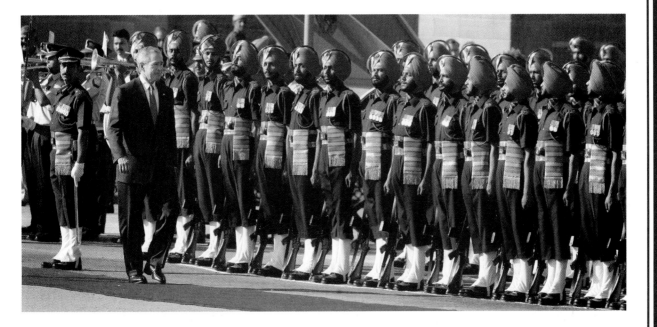

George W. Bush inspecting taxi cab driver recruits in New Delhi.

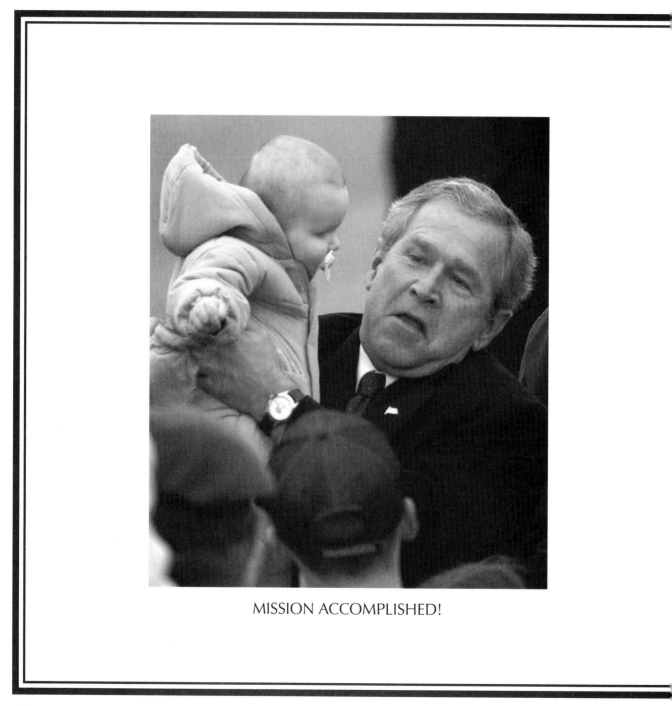

MISSION ACCOMPLISHED!

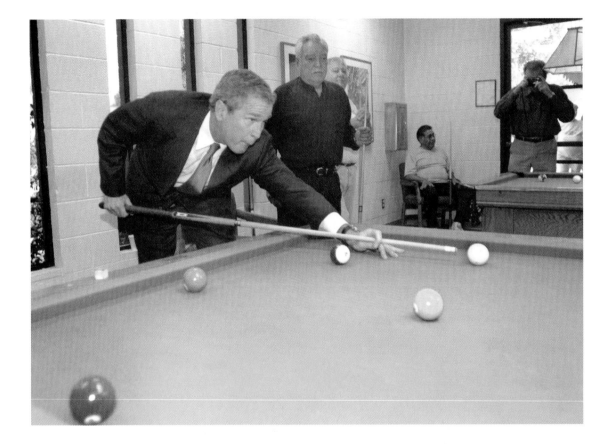

Bush calls his shot. "Cue ball in the corner pocket."

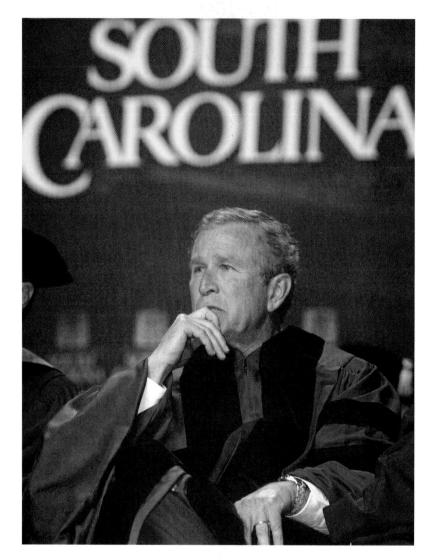

"Now lemme see, am I in North or South Carolina?"

For want of a nail the kingdom was lost.

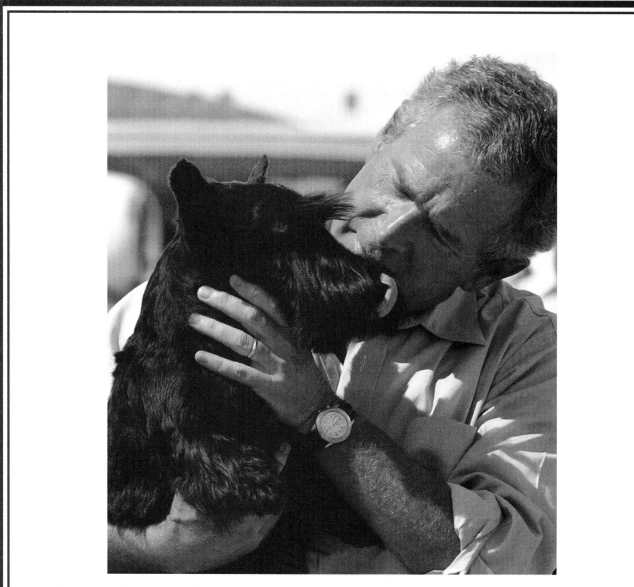

Temporarily without Congressional cover, Bush pretends that cuts to Head Start and Americorps are actually coming from his dog Barney.

"I wonder if Big Dick will ever let me pitch."

Pastor checks to see if there's light at the end of the tunnel.

"Hi, ho. Hi, ho. It's off to catch illegal immigrants we go."

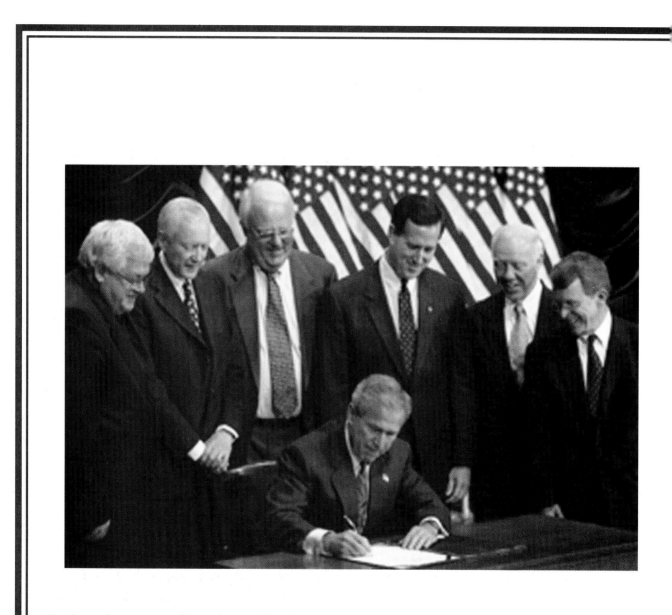

Bush and a group of his closest theological advisers take a solemn vow never to personally undergo an abortion.

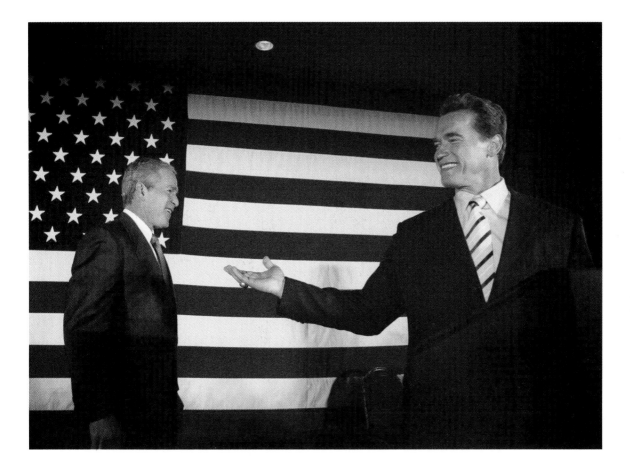

Where but in America could the son of a simple Nazi police chief get to meet
the son of the former head of the CIA?

CIA report on Iraq finally came through!

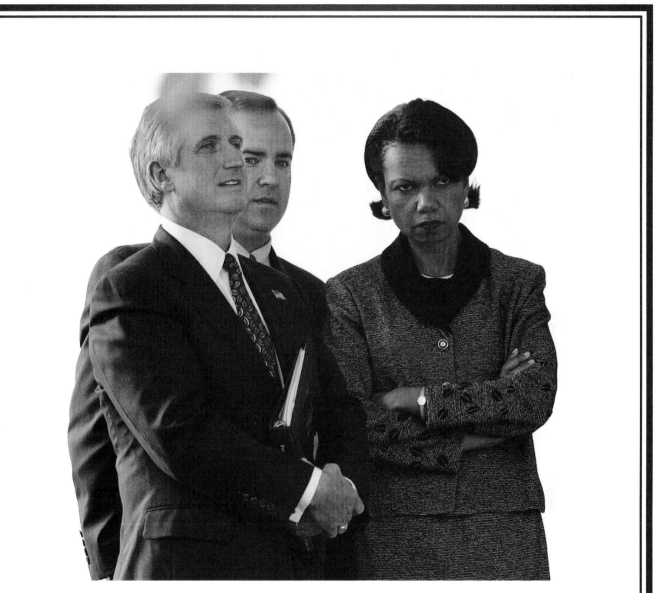

"Who's gonna tell him his fly is down?"

Bush pays a surprise visit to a group of suspected liberals confined in one of the many "Homeland Security Camps" established under the Patriot Act.

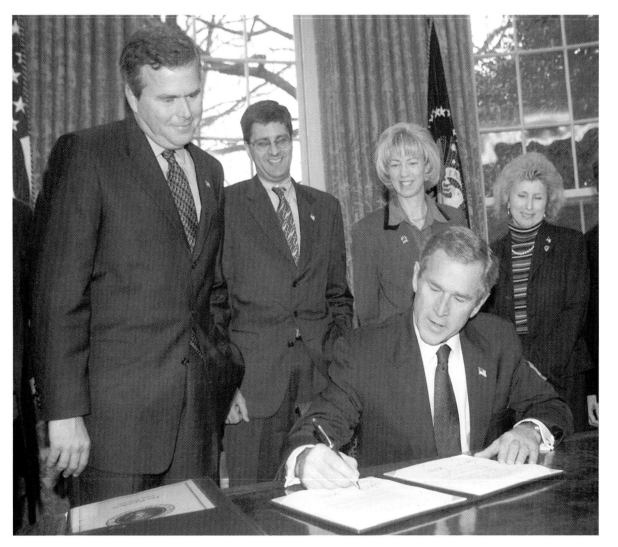

Bush signs bill leaving Republic to younger brother Jeb. Jeb promises eight years of tax cuts, hyper-conservative judicial appointments and "war with . . . I dunno . . . somebody . . . maybe Peru."

Bush demonstrates the "intentional grounding" tactic used when the QB can find neither an open receiver nor a single Weapon of Mass Destruction.

Wolfowitz assures Bush that despite "certain minor unforeseen difficulties" in Iraq, North Korea will be "a slam dunk".

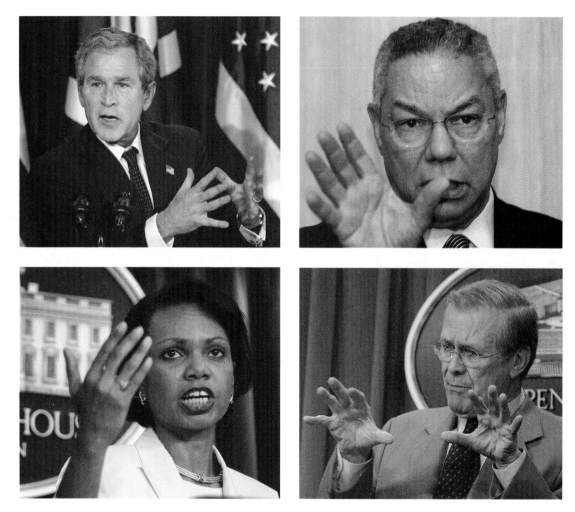

Watch very carefully. Notice our fingers never leave our hands.

And ZAP! The surplus has vanished!

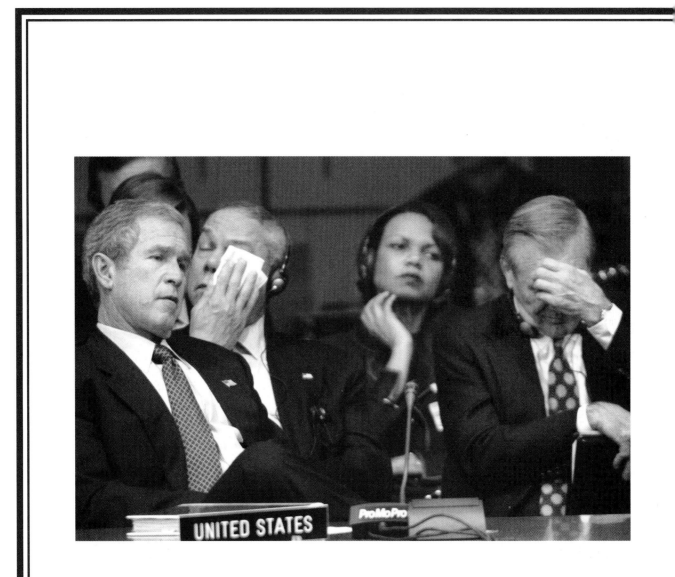

His closest advisors are learning to accommodate the President's lactose intolerant condition.

"Boy, did I just stink up this place."

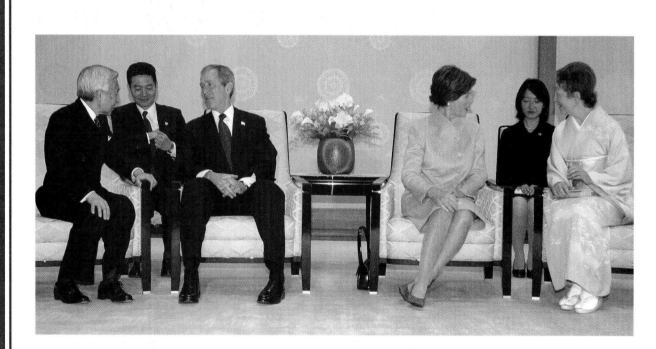

On Asian tour, presidential translator struggles to find Japanese word for "economyize," while God, in his mercy, permits the First Lady's translator to fall asleep.

"I can't tell you the last time I wore one of these. I'm serious. Those whole three years are a blur."

"There's gonna be hell to pay when I find out who leaked this to the liberal media!"

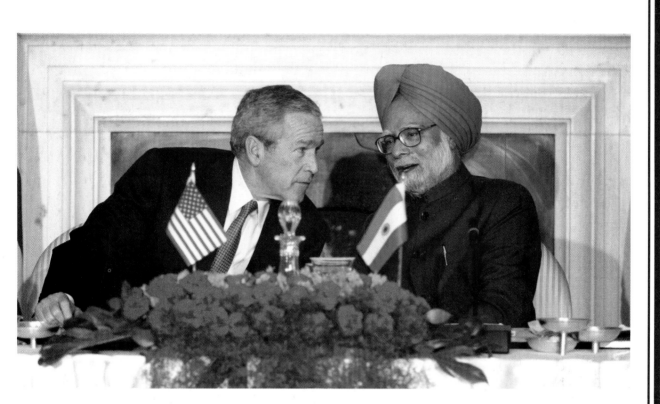

Prime Minister Singh assures Bush that India will use nuclear weapons "only against Muslims."

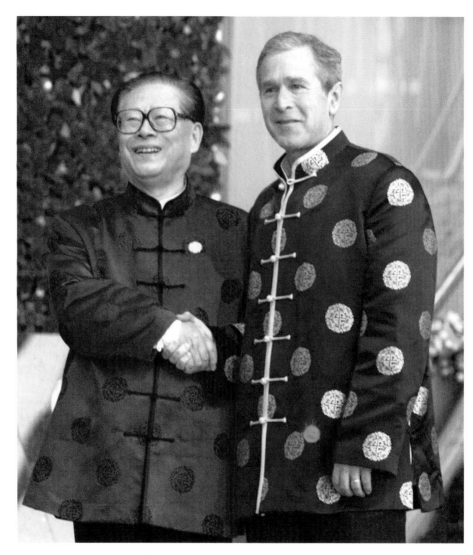

Bush thanks Zemin for the nifty PJs.

"Say … bullshit!"

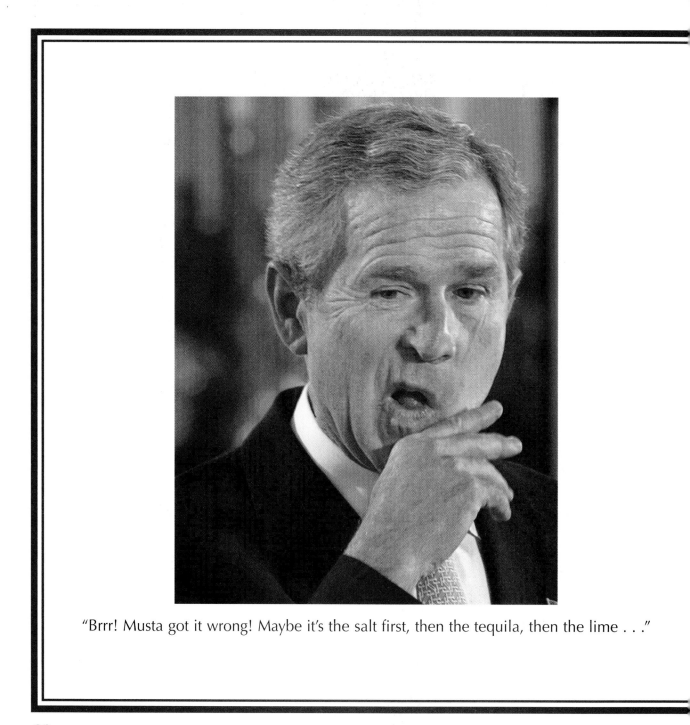

"Brrr! Musta got it wrong! Maybe it's the salt first, then the tequila, then the lime . . ."

"Nope. Maybe I'll follow Dick's example and take a shot."

An enthusiast for "X-treme Sports," the President executes the difficult "Freestyle Segway Double Klutz with Full Face-plant."

"Mission accomplished. Hello? I said Mission Accomplished!"

Photo Captions

Cover. President Bush answers questions from reporters during a press conference in the Brady Press Briefing Room in the White House, March 21, 2006.

Page 5. President Bush participates in a panel on health care initiatives at the U.S. Dept. of Health and Human Services in Washington, February 16, 2006.

Page 6. President Bush reaches down to pick up a copper cable used to protect a tree in the South Lawn of the White House from lighting strikes, February 22, 2006.

Page 7. President Bush accidentally drops his dog Barney to the tarmac upon arrival in Waco, TX, August 30, 2003. Barney was not hurt.

Page 8. President Bush, in Crawford, TX, November 5, 2002, reacts to a child who asks him if he would attend the child's birthday party. The president replied that the invitation must have been lost in the mail.

Page 9. US Defense Secretary Donald Rumsfeld, wearing a workout outfit, enters his car in Munich, Germany, Feb. 3, 2006.

Page 10. President Bush helps fill in erosion damage with volunteers during a visit to Santa Monica mountains in Thousand Oaks, CA, August 15, 2003.

Page 11. President Bush speaks on homeland security and the budget at the base of Mount Rushmore National Memorial in South Dakota, August 15, 2002.

Page 12. President Bush and Secretary of State Powell arrive in Rome for a meeting with European heads of state, May 27, 2002.

Page 13. President Bush passes a saluting Marine as he returns to the White House via helicopter, September 4, 2003.

Page 14. President Bush speaks on the economy while visiting Beaver Aerospace and Defense in Livonia, MI, July 24, 2003.

Page 15. President Bush addresses the Republican National Committee gala in Washington, DC, October 8, 2003.

Page 16. President Bush sits in front of a painting of Jesus Christ as he addresses Teen Challenge of the Midlands at their meeting in Colfax, IA, June 21, 2000.

Page 17. Vice President Cheney addresses the National Minority Enterprise Development Week Conference at a Washington hotel, September 30, 2003.

Page 18-19. Vice President Dick Cheney looks towards President Bush as he makes a statement to reporters in the Rose Garden, Tuesday, March 28, 2006.

Page 20. President Bush, a portrait, tight lipped.

Page 21. President Bush photographed with a scowl on his face, July 3, 2002.

Page 22. President Bush sits with the National Security Council during a meeting in the White House September 12, 2001. With him are Secretary of State Powell, left, and Vice President Dick Cheney.

Page 23. Vice President Dick Cheney stands in the Oval Office at the White House during a meeting between President Bush and South Korean President Kim Dai-jung, March 7, 2001.

Page 24. President Bush gestures to his dog, Spot, on the White House lawn after returning from a trip to New Jersey, September 23, 2002.

Page 25. President Bush dons safety glasses as he tours the Johnson Controls Battery Center in Glendale, WI, February 20, 2006.

Page 26. President Bush participates in a panel on health care initiatives at the U Dept. of Health and Human Services Washington, February 16, 2006.

Page 27. French President Jacques Chi kisses the hand of Laura Bush upon arrival for a courtesy call at the Ely Palace in Paris, September 29, 2003.

Page 28. National Security Advisor Ri Secretary of State Powell and Vice Presid Cheney confer in the White House prior a meeting with the President, June 6, 200

Page 29. President Bush and Israeli Pri Minister Ariel Sharon laugh while mak statements in the Rose Garden in Washington, July 29, 2003.

Page 30. President Bush meets the Da Lama in the White House, September 2001.

Page 31. President Bush answers a questi from the audience during remarks on sec ing America in Tampa, FL, February 2006.

Page 32. Top: President Bush in Bridgep CT, April 9, 2002; bottom left: in Washington, D.C., September 4, 2003; bott right: in Chicago, September 30, 2003.

Page 33. Top left : in Milwaukee, Octobe 3, 2003; top right: in Portsmouth, N October 9, 2003; bottom: with Powell a Rumsfeld, Washington, November 6, 200

Page 34. President Bush pretends to throw ball to visiting youngsters as he heads for helicopter on the White House law September 26, 2003.

Page 35. Carl Rove runs across the So Lawn toward Marine One at the Wh House in Washington, D.C., April 19, 200

Page 36. President Bush speaks to the cr of the carrier USS Abraham Lincoln, dec ing that major combat actions in Iraq complete, May 1, 2003.